My Style

My drawing style mainly consists of a huge variety of patterns, shapes, lines, and dots, all mixed together to create intricate compositions with a high visual variation. It has elements of multiple art styles, like dotwork, black and white linework, Zentangle® art, medieval ornament, etc. It is heavily influenced by nature—my all-time favorite subject is animals. When it comes to coloring, although I'm not a professional colorist, I always choose an approach that guarantees a certain precision, and I love making my designs look three-dimensional and shiny, as if they're made of metallic elements.

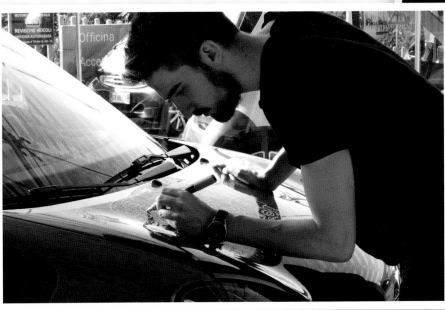

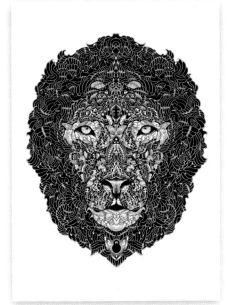

In summer 2015, the Smart car company asked me to customize the new Smart ForTwo for an event in Alghero, Sardinia. I painted every inch of the car except for the glass and the wheels with Uni Posca paint pens.

This piece is part of a series of three illustrations called "Winged Wildlife Series." I created it in early 2014 with pen and ink and then proceeded to edit it and color it digitally.

This is part of my "Simpson Family" series, a personal work from early 2015. I was experimenting with portraits done in my decorative style. The inking part is all freehand—I didn't draw it in pencil first.

This lion from 2014 is one of the first pieces I did in my ornate style, and it's possibly the most successful one. It's probably my favorite work to this day.

Coloring Tools

As you may know, there are tons of different coloring tools and mediums out there, each one with its own characteristics. There's not a right or a wrong one to use; you just have to find the one that suits your coloring style best. I personally try to use a wide variety of art supplies; I love experimenting, and I feel that changing your medium from time to time keeps your art unique and intriguing. Here are a few examples of art tools that I like, along with some of their pros and cons.

Alcohol-Based Markers: These are excellent when it comes to blending colors together and creating nice, smooth gradients. Since my coloring style has the goal of making the design look 3-D, I use alcohol-based markers frequently. They can be a little expensive, and they do bleed through thin paper, but they're definitely amazing art supplies.

Water-Based Markers: Run-of-the-mill, inexpensive markers are water-based instead of alcohol-based. They usually don't layer on top of each other or blend very well. But they're pretty useful for flat and basic coloring, and may be a good starting point for a beginner. I don't use these often.

Colored Pencils: If you're not a big fan of markers, colored pencils are probably the best alternative you have. They come in a ridiculous number of different colors and values, they're usually less expensive than alcohol-based markers, and you'll be able to blend them together nicely. They also don't bleed through paper, but they can scratch it if you apply too much pressure. Overall, they're great for coloring and highly recommended for both professional artists and amateurs.

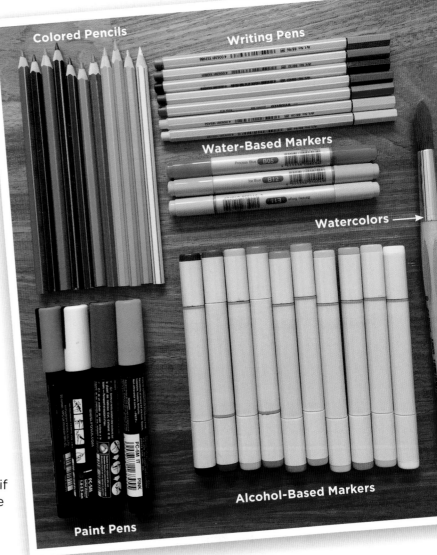

Paint Pens: Paint pens use an oil-based paint and generally require shaking before use. Their coolest feature is that they can overlay all other colors and mediums beneath them, making them perfect for patterning and detailing. Just imagine adding lines and shapes with a white paint pen to an already dry, layered gradient! They are sometimes quite expensive, but definitely worth a try. Gel pens (not pictured) are a tamer, less expensive version of paint pens that also layer on top of other colors. You can also use normal writing pens to add detail.

Watercolors: Probably my least favorite medium (solely because I'm terrible at using them!), watercolors generally require a higher level of ability to execute well. On the other hand, watercolors can create some great effects: you can layer and blend them and create light and shadow areas, and they give your piece great texture. You can find inexpensive watercolors, but if you're looking for the more prestigious quality brands, you'll have to invest some money. Or you can try using watercolor pencils, which are a way to create a watercolor effect without the need for high-level painting ability.

Picking Your Color Palette

Many people say they have trouble knowing where to start with a coloring page, especially when it comes to coloring big, heavily-detailed designs. The smartest thing to do is to start with a simple decision. One concrete decision you can make is choosing your color palette: all the colors you're going to use for a certain illustration. Here are a few golden rules for picking color palettes that will make them look amazing.

- **Don't pick randomly.** Generally speaking, choosing colors logically helps keep the drawing coherent and avoids unnecessary visual mess. But if one day you just feel like being adventurous, go ahead and do it! Your ultimate goal should be to have fun.

- **Give a "temperature" to your drawing.** That might sound weird at first, but it essentially means that choosing a palette of warm colors or cool ones is always a smart idea. You can also mix a few warm tones with some cool ones (I do that all the time), and it will create an interesting composition. Again, experiment! Have a blast!

- **Practice your layering and blending.** Layering and blending are two very easy-to-learn concepts that, when used correctly, will make your drawing look extremely cool, almost alive! (See page 4 for more info on layering and blending.)

Here are a few examples of winning color palettes for you.

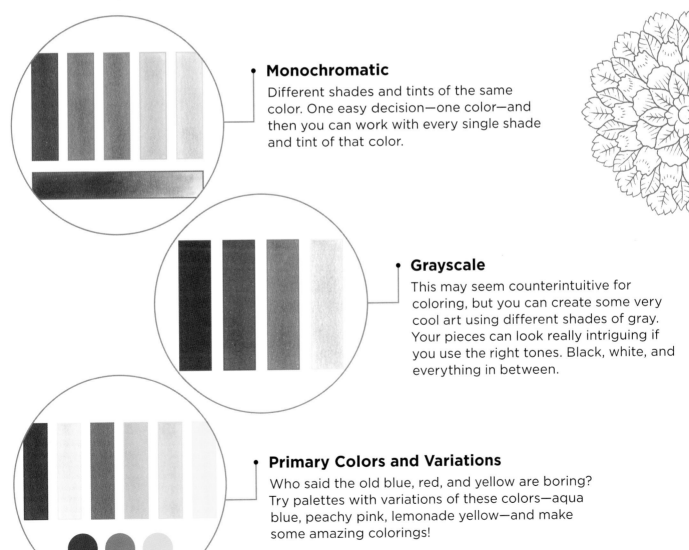

Monochromatic
Different shades and tints of the same color. One easy decision—one color—and then you can work with every single shade and tint of that color.

Grayscale
This may seem counterintuitive for coloring, but you can create some very cool art using different shades of gray. Your pieces can look really intriguing if you use the right tones. Black, white, and everything in between.

Primary Colors and Variations
Who said the old blue, red, and yellow are boring? Try palettes with variations of these colors—aqua blue, peachy pink, lemonade yellow—and make some amazing colorings!

Layering and Blending

As I said earlier, these are two of the most useful techniques when it comes to coloring. They can help you give structure, shading, and contrast to your design, and they're super easy to learn. In the following steps, I will show you layering and blending with alcohol-based markers, but many drawing mediums will do just fine. You can use colored pencils, crayons, ink pens, paint pens, gel pens, or watercolors and achieve very similar results, though the quality of your blends will depend on the particular medium and on the quality of the products.

1 Base tone

Lay down a base layer with your lightest color. Make sure it's flat and even for best results. If you're using colored pencils, make sure you always apply the color in light strokes without pressing too hard on the paper.

2 Middle tone

Proceed by laying down your middle tone on part of the first layer, and then use strokes of your lightest color to smooth out the color and make the shading look more gradual.

3 Dark tone

Time to color in with your darkest shade! Repeat the process shown in the previous step, first applying your darkest tone and lightly smoothing out the transition with the middle tone. Then go over the entire area once more with your lightest color for maximum blending and smoothness.

4 Details (optional)

Now for the fun part! When the ink/pigment is nice and dry, you can add details and patterns using many different media (gel pens, paint pens, white ink, fine-tip markers, etc.). Go nuts!

Bonus Tips

- **Perseverance**

 Let's say you've colored a portion of the design, but you don't really like it. Keep going and don't give up! Sometimes you will create some of your best pieces working through bad starts—trust me, I've experienced this many times myself.

- **Relax!**

 One of the most beneficial aspects of coloring is its ability to relax you and put you in a good mood. Try listening to some soothing music or audiobooks while you color for an even better experience. I personally love listening to original movie soundtracks while I work, but any genre might work great for you.

- **Paper Protection**

 If you're coloring directly in the book, and you notice when you're coloring with a certain medium (like alcohol-based markers) that some of the ink is bleeding through the page, just place a blank sheet of paper beneath the drawing; this will protect the design on the following page of the book.

- **Tool Maintenance**

 When using colored pencils, always make sure to keep them sharp and be careful not to drop them. This will preserve the pigment inside and make them last a lot longer. If you're using markers, always put their caps back on when you're not using them. If the ink inside dries up too much, the marker will stop working.

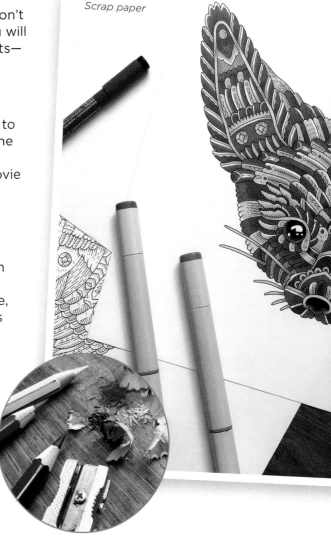

Scrap paper

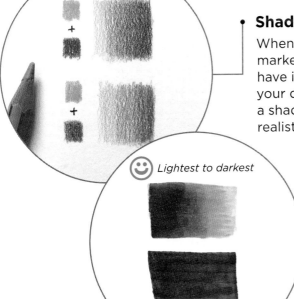

- **Shadows**

 When coloring in shadow areas, don't use a black pencil or marker. Try using a complementary color to the one you have in the lighter areas (for example, if that element of your drawing is orange in its light- and mid-tone areas, use a shade of blue to build up your shadow). This will create a realistic, soft brown/gray shadow.

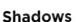

☺ *Lightest to darkest*

Darkest to lightest ☹

- **Color Order**

 Always apply colors from the lightest to the darkest. This way you can achieve far better blending and gradients, and you can also go over mistakes with a darker tone if you mess up.

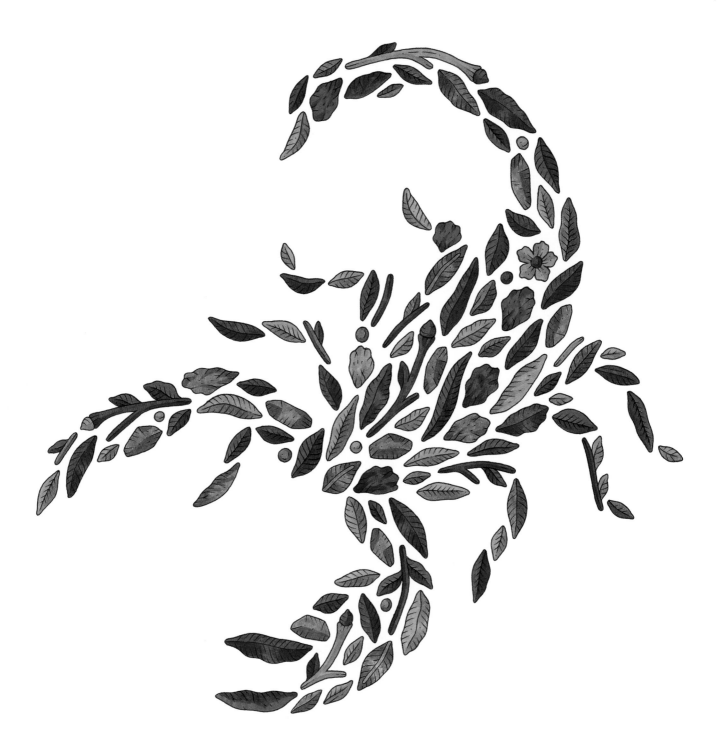

6 *The Sting, page 47.*
Markers (Copic). Color by Filippo Cardu.

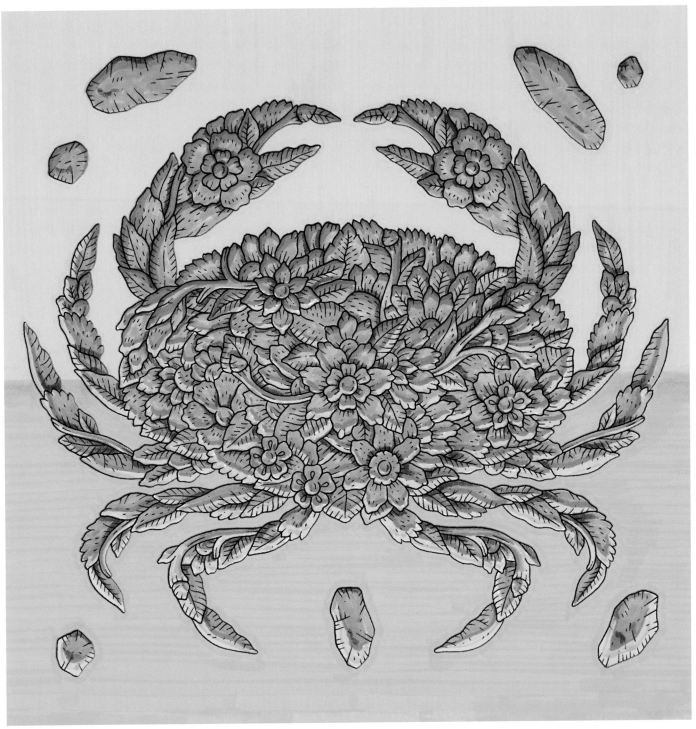

Happy Crab, page 41. 7
Markers (Tombow, Marvy, Sakura). Color by Justin Speers.

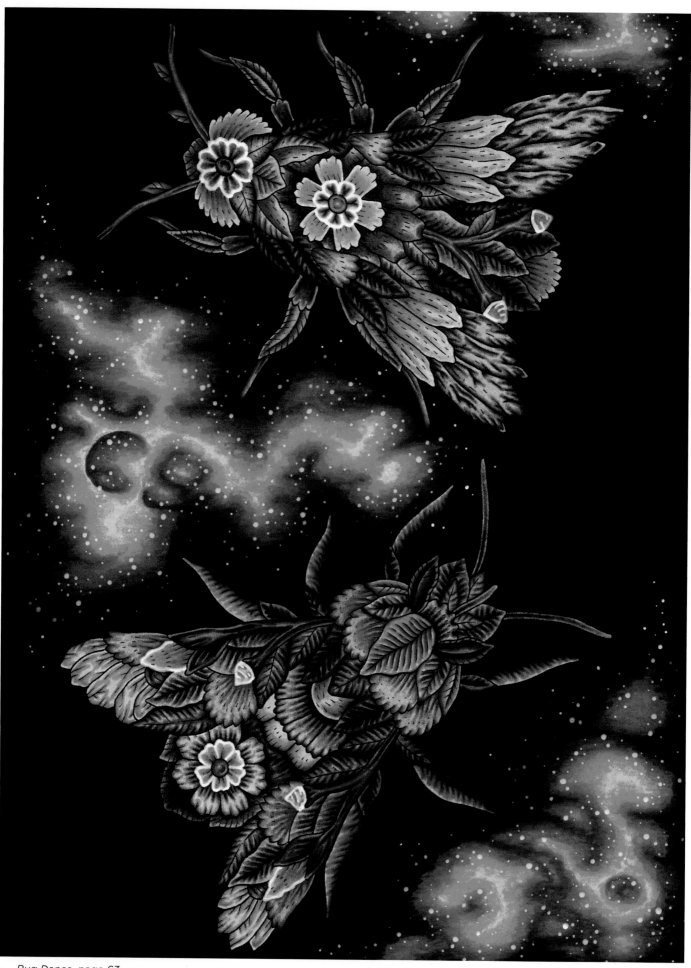

8 *Bug Dance, page 63.*
Pens (Stabilo, Faber-Castell), gel pens (Uni-Ball), paint pens (Posca). Color by Fanny Viola (Instagram: @faynnn).

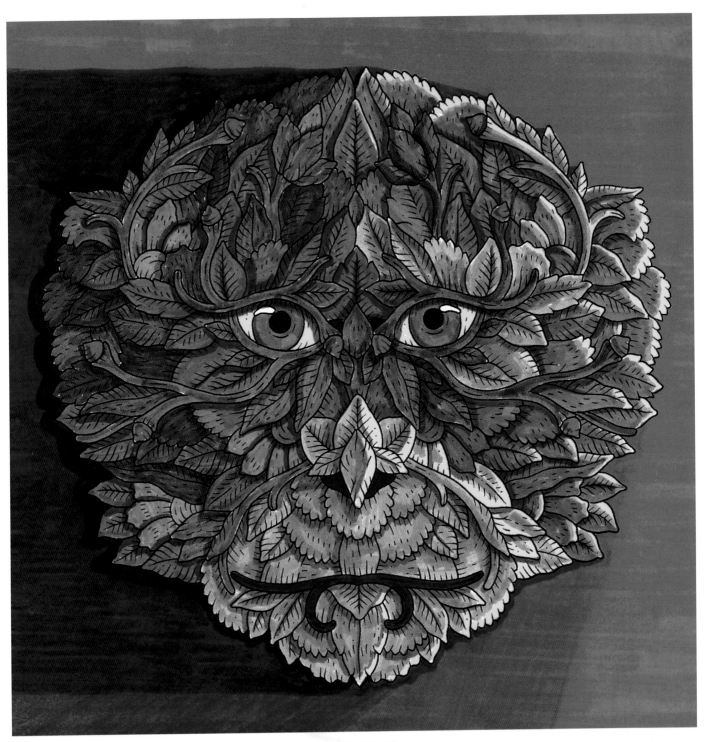

 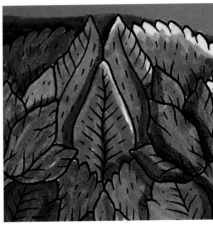

Curious Eyes, page 39. 9
Markers (Tombow, Marvy, Sakura). Color by Justin Speers.

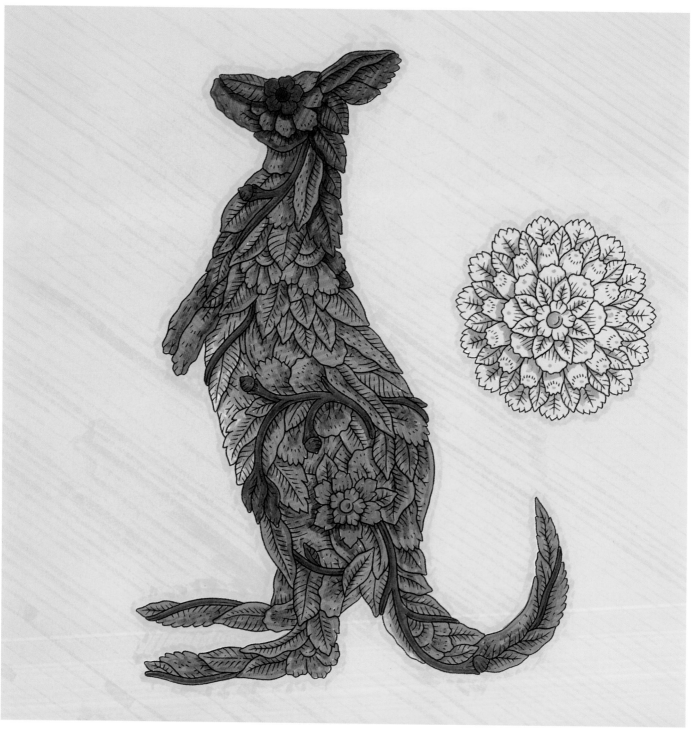

10 *Capering Kangaroo, page 35.*
Markers (Tombow, Marvy, Sakura). Color by Justin Speers.

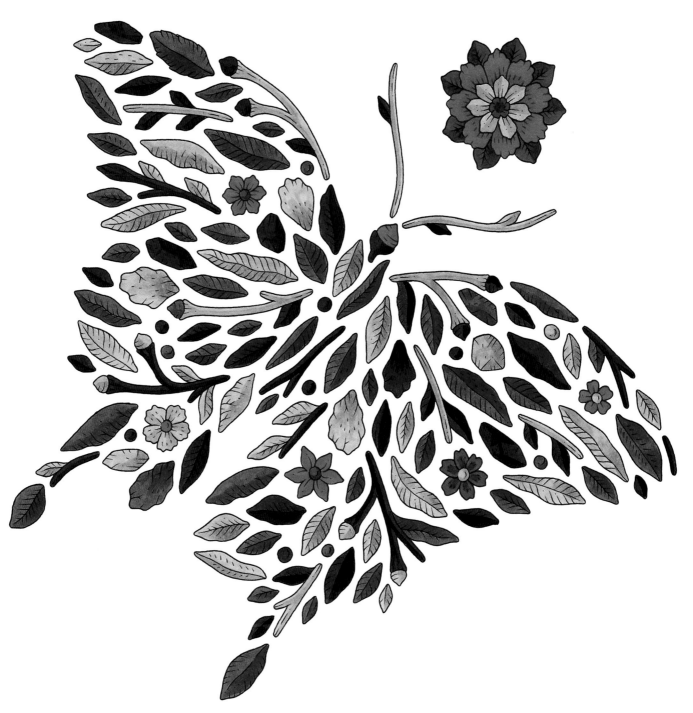

Flying Flower, page 43. 11
Markers (Copic). Color by Filippo Cardu.

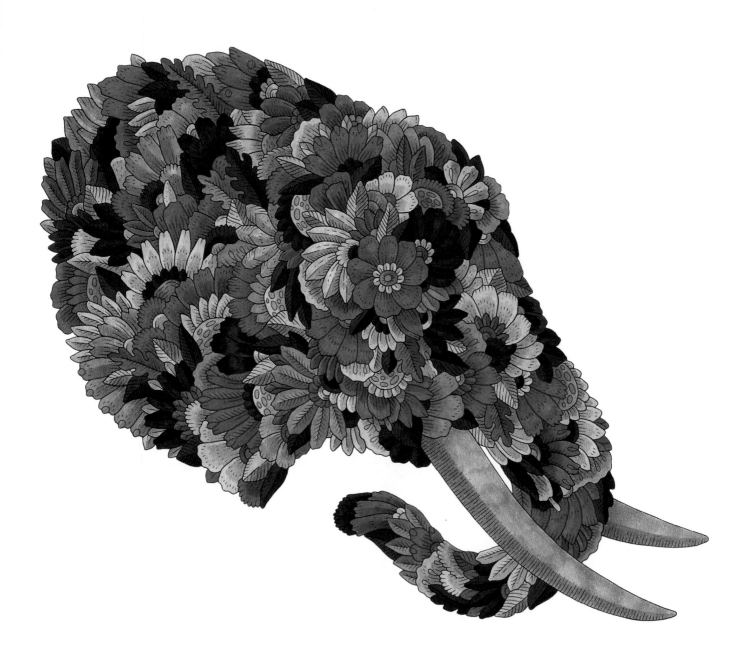

12 *Elephant Blooms, page 45.*
Markers (Copic). Color by Filippo Cardu.

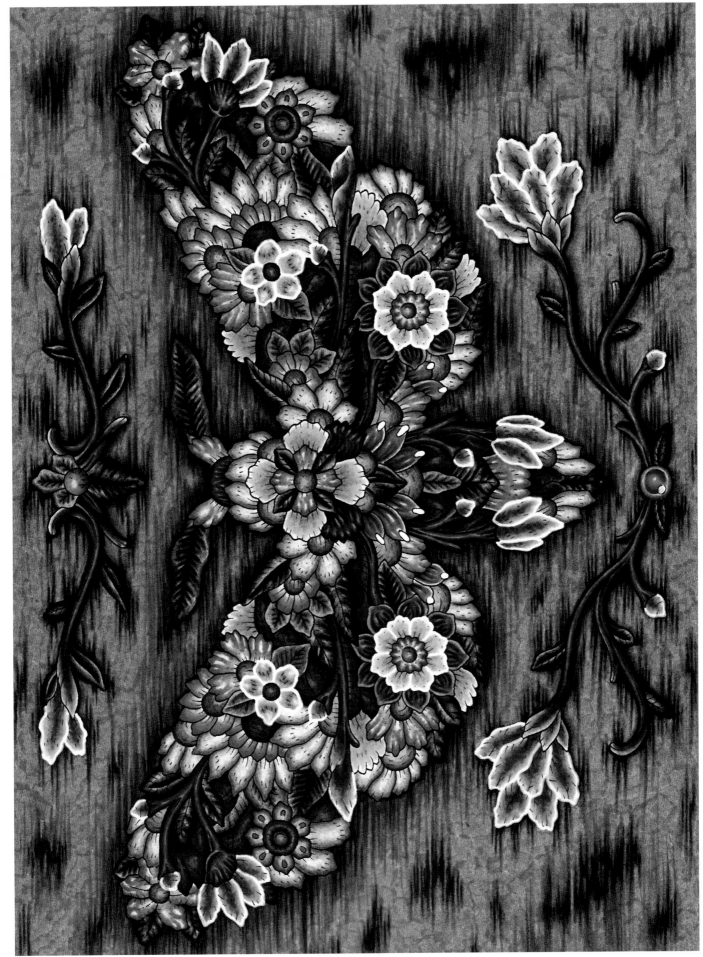

Spread Your Wings, page 49.
Pens (Stabilo, Faber-Castell), gel pens (Uni-Ball). Color by Fanny Viola (Instagram: @faynnn).

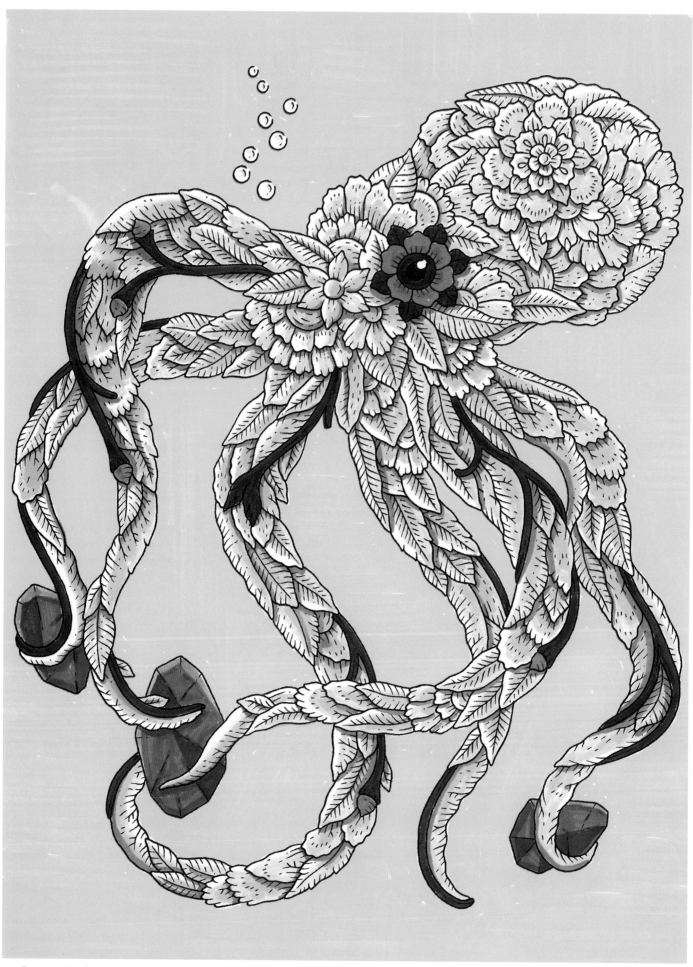

14 *Octopus Exploration, 21.*
Markers (Tombow, Marvy, Sakura). Color by Justin Speers.

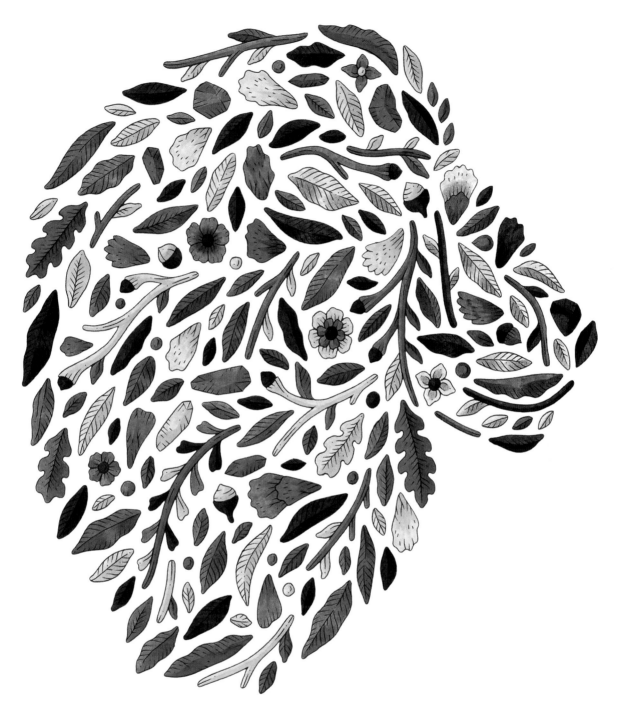

Profile of Courage, page 37.
Markers (Copic). Color by Filippo Cardu. 15

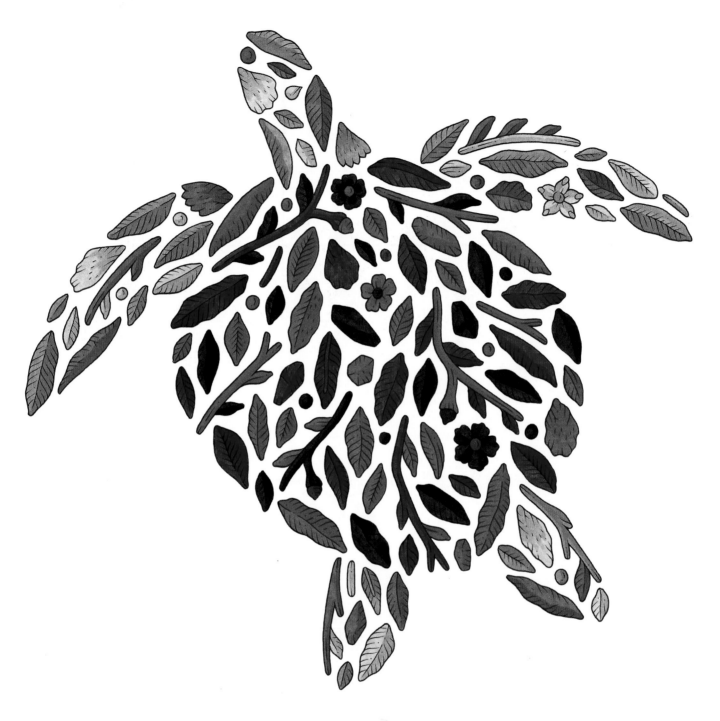

16 *Floating Along, page 33.*
Markers (Copic). Color by Filippo Cardu.

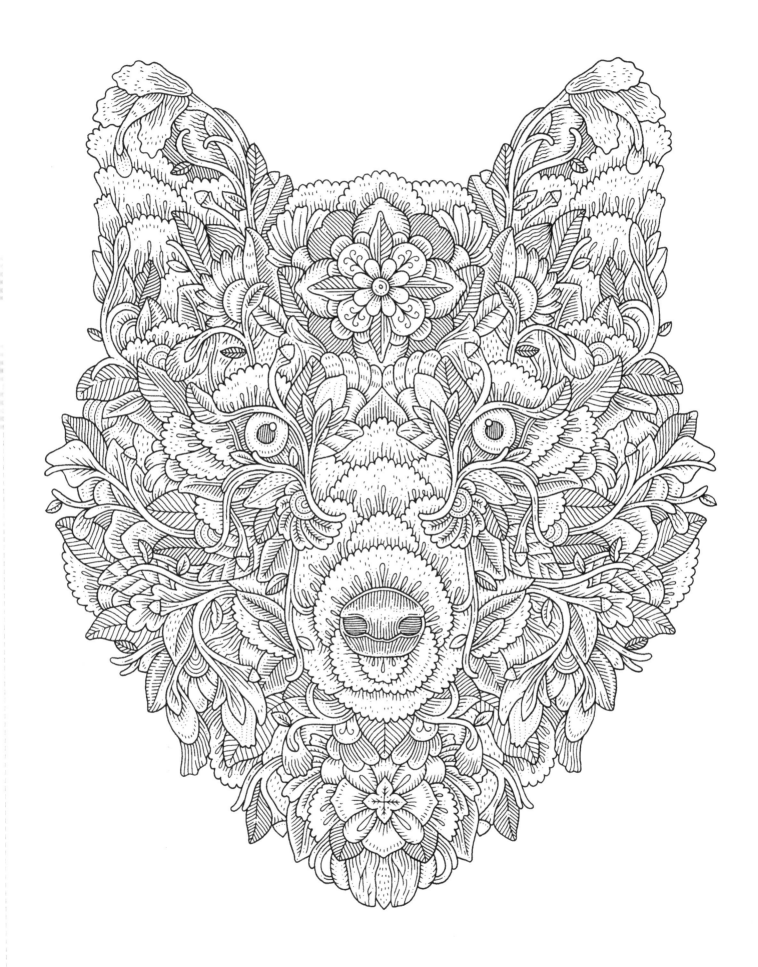

The gaze of the wolf reaches
into our soul.

—**Barry Lopez**

Lone Wolf

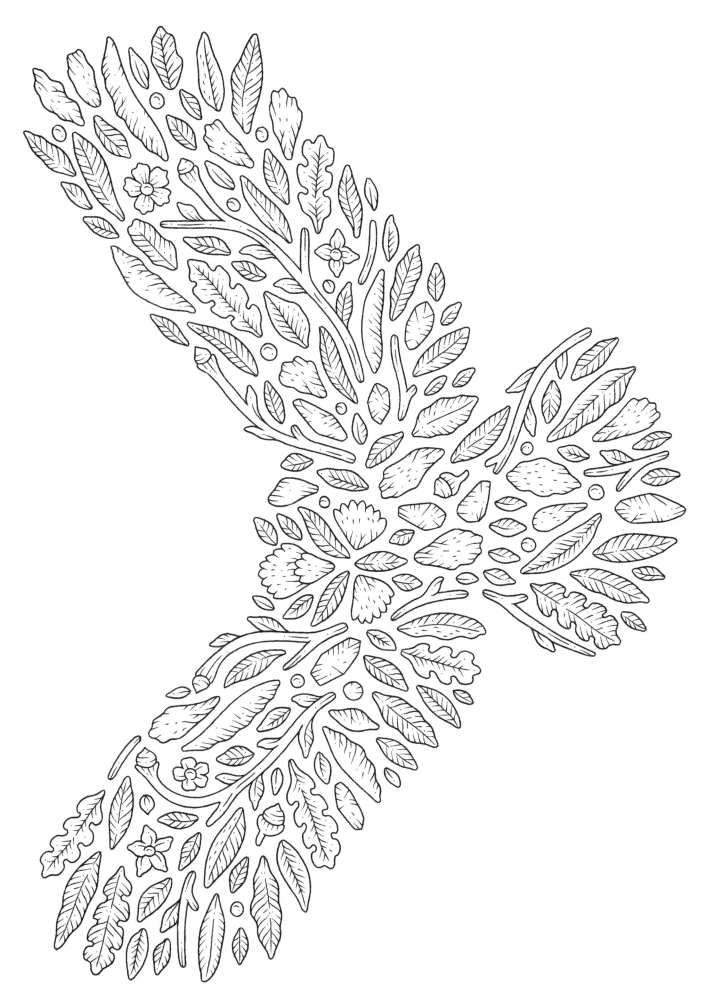

Birds have wings; they're free;
they can fly where they want when
they want. They have the kind of
mobility many people envy.

—Roger Tory Peterson

Flight

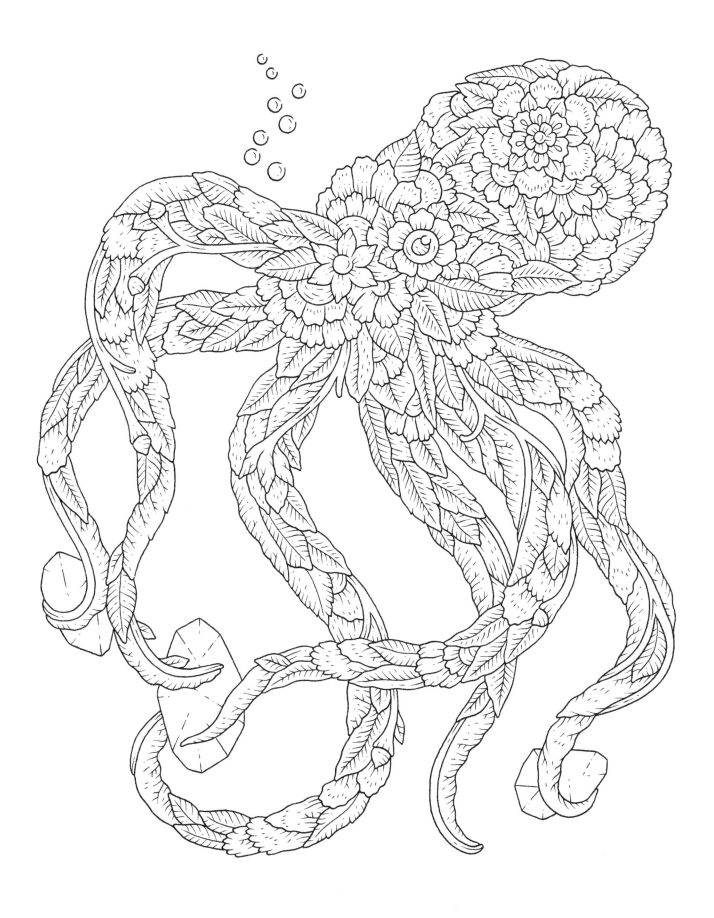

Same old eyes, same old world,
but the difference is how you look at what is
in front of you, not what it is.

—Lister Sinclair

Octopus Exploration

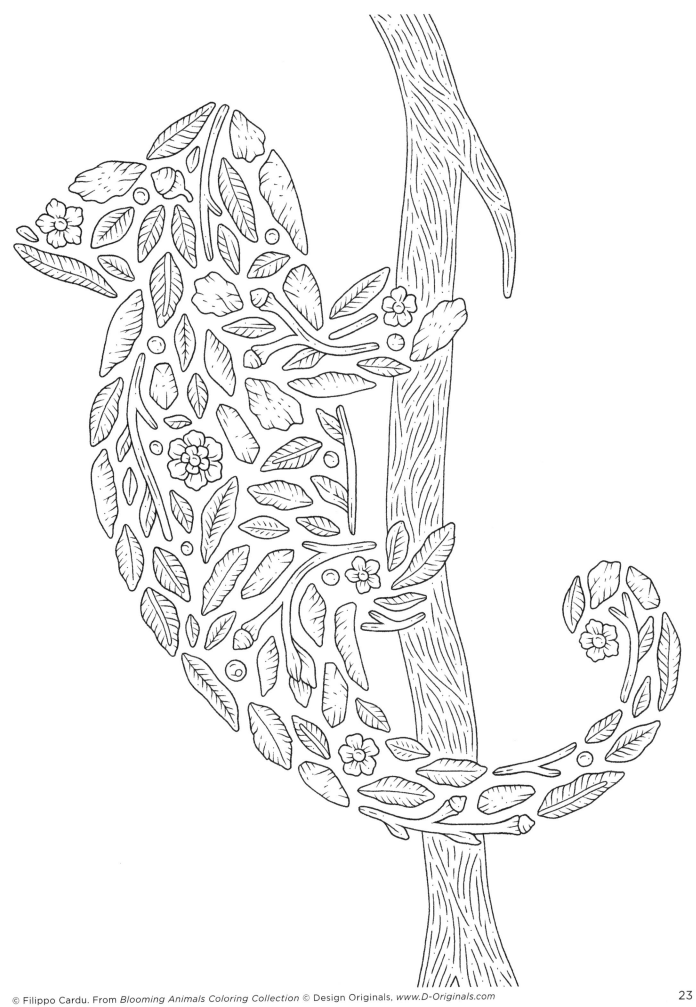

Each species is a
masterpiece, a creation assembled
with extreme care and genius.

—Edward O. Wilson

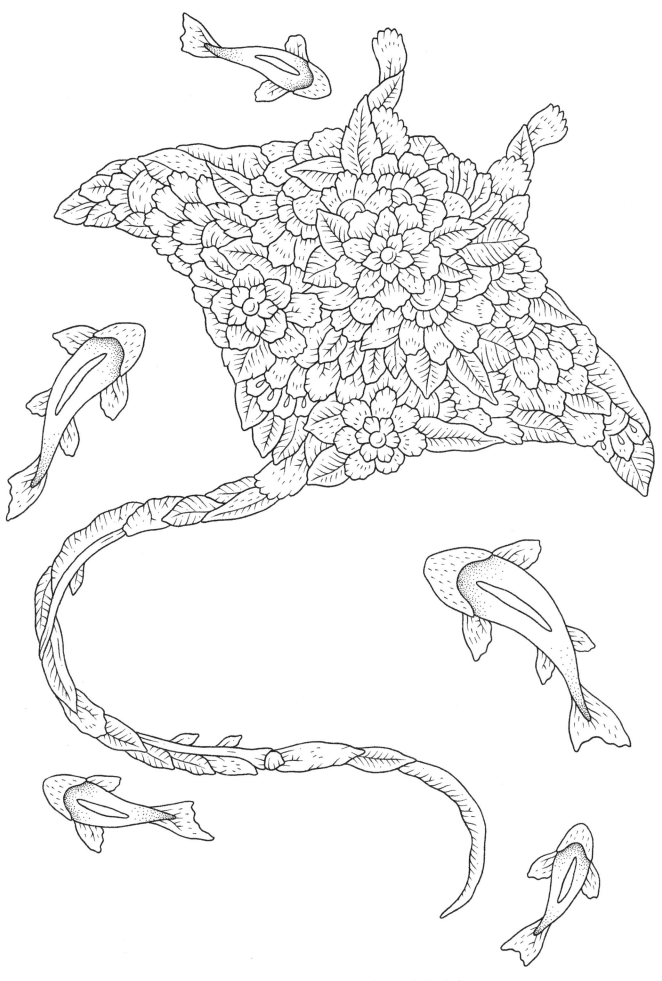

The mountain and the sea are excellent schoolmasters, and teach some of us more than we can ever learn from books.

—John Lubbock

A Fish Called Ray

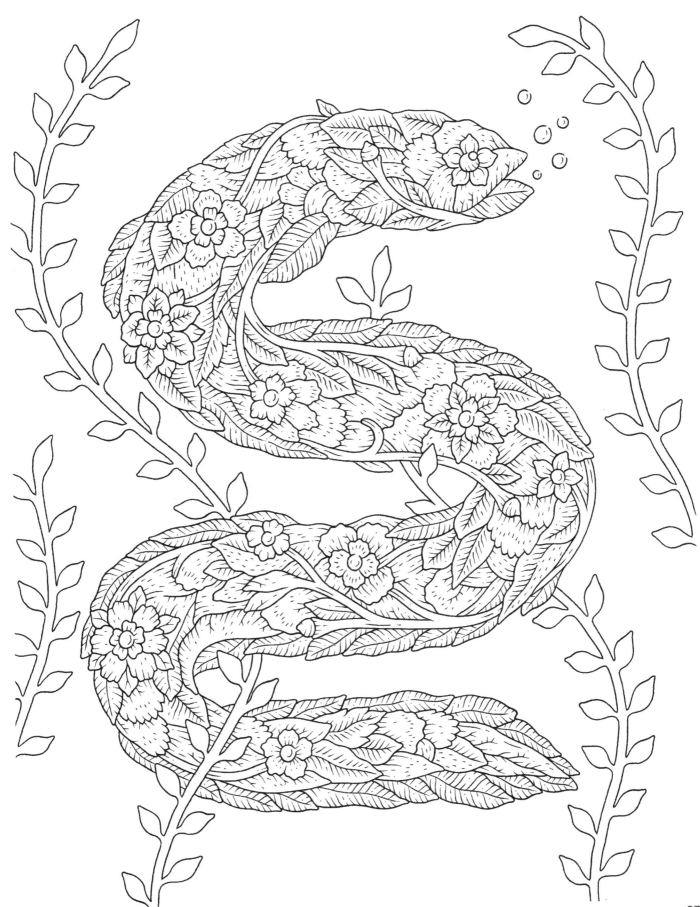

The ocean makes me feel
really small and it makes me put
my whole life into perspective.

—Beyoncé Knowles

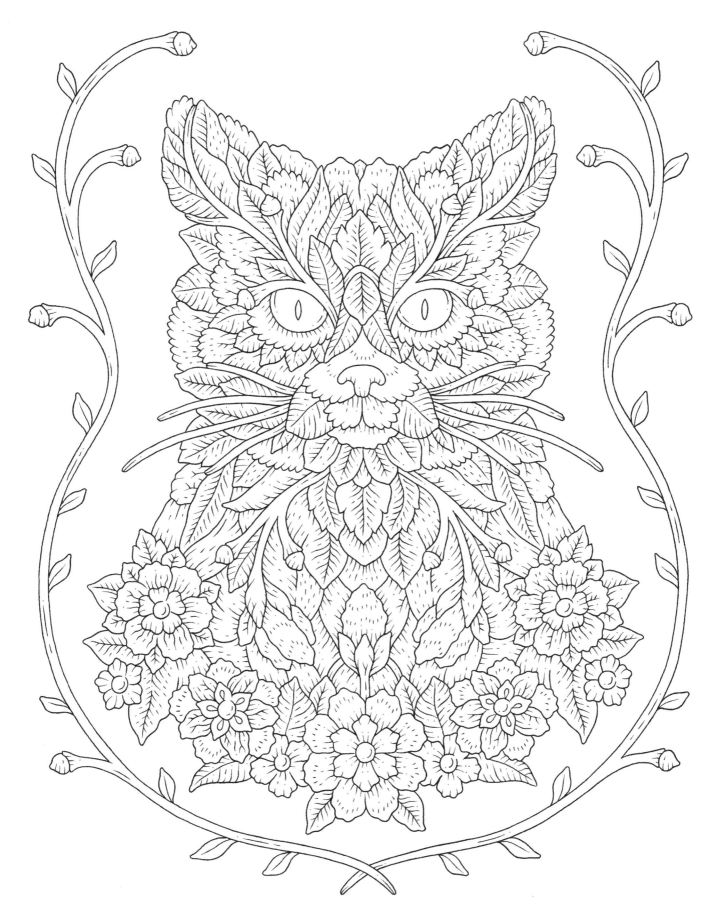

God made the cat in order
that man might have the
pleasure of caressing the lion.

—Fernand Méry

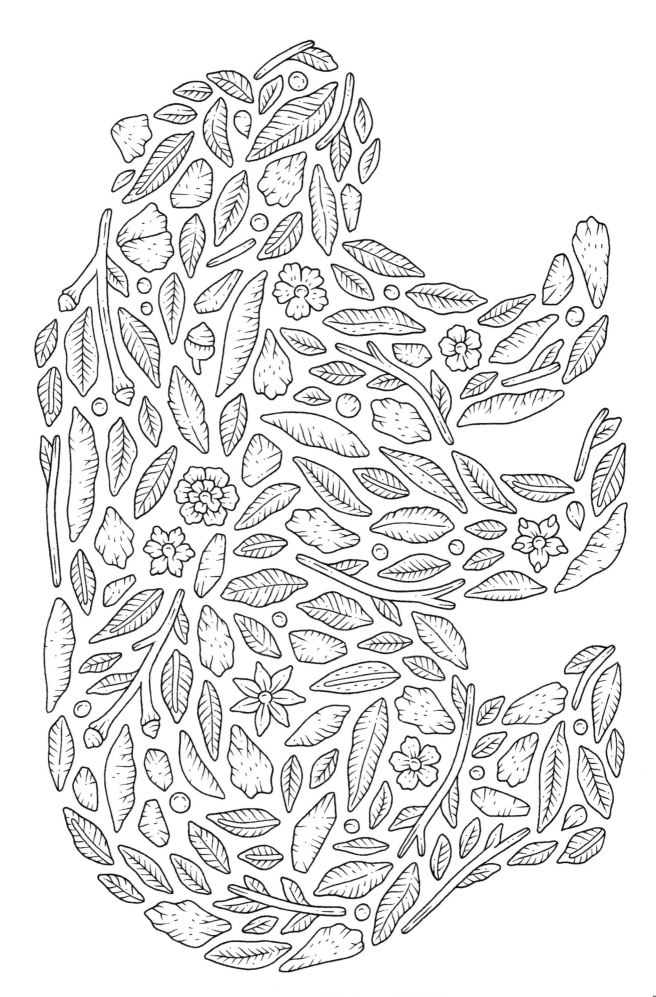

In wilderness I sense the miracle of life, and behind it our scientific accomplishments fade to trivia.

—**Charles A. Lindbergh**

Bold Bear

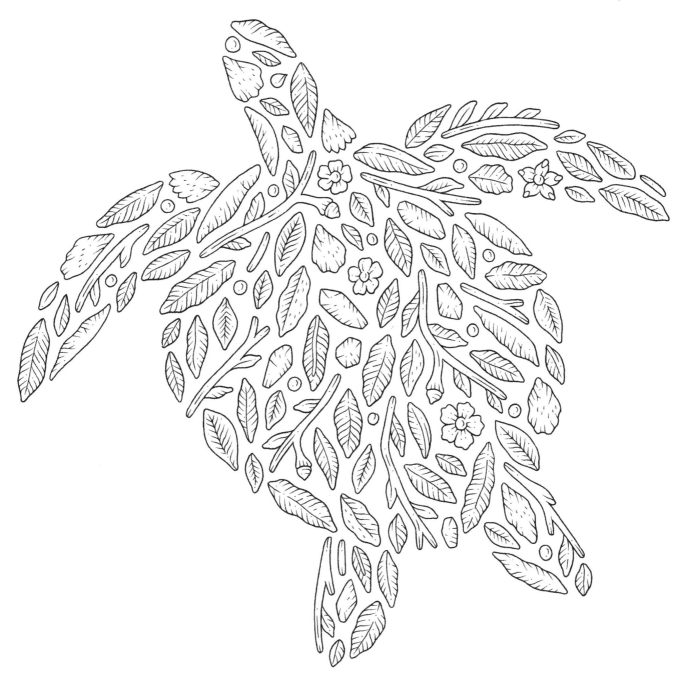

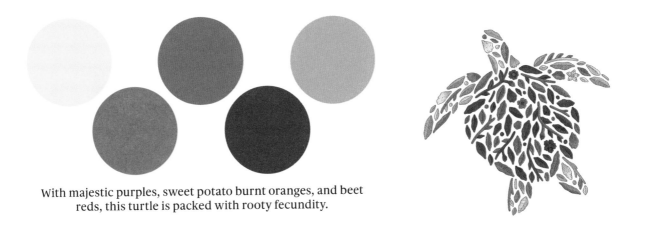

With majestic purples, sweet potato burnt oranges, and beet reds, this turtle is packed with rooty fecundity.

Slow and steady wins the race.

—Aesop

Floating Along

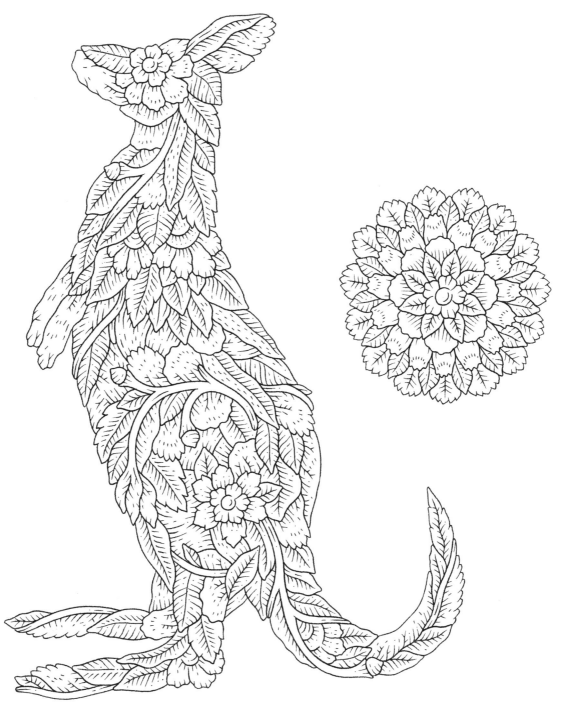

A burst of sunny yellow punctuates this otherwise cool and floaty scene.

Like music and art, love of nature is a
common language that can transcend
political or social boundaries.

—Jimmy Carter

Capering Kangaroo

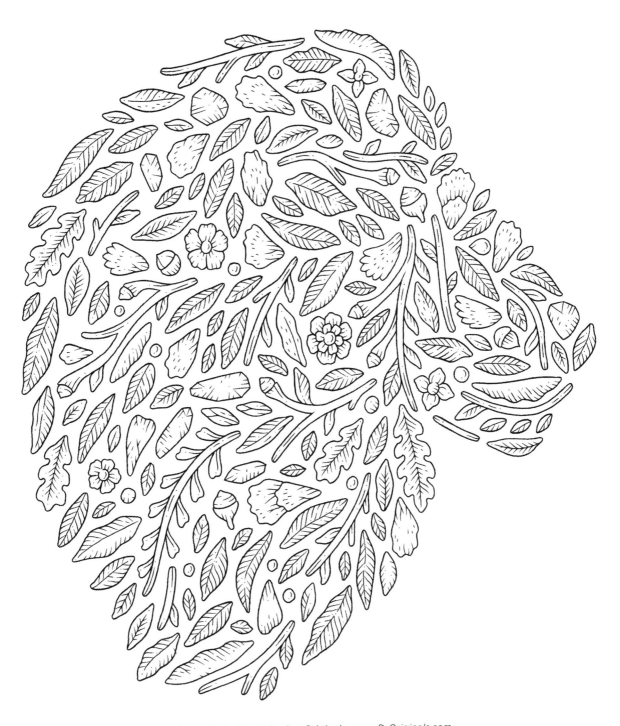

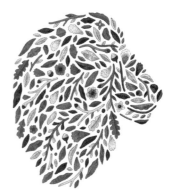

Watery blues, irregular shapes, and fine line work create an
unexpected marblesque texture for this lion's mane.

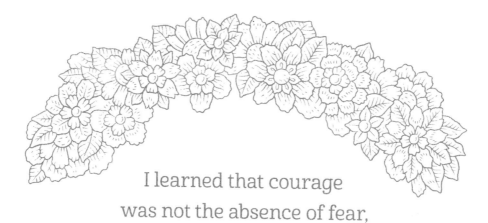

I learned that courage
was not the absence of fear,
but the triumph over it.

—Nelson Mandela

Profile of Courage

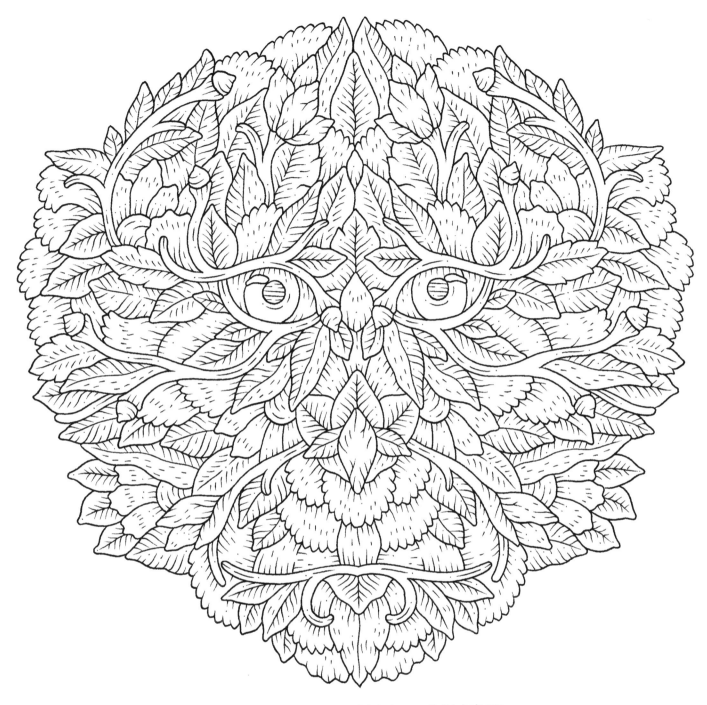

A brilliant flare of light from off the page gives this
almost-human face the gravitas of a 1970s movie poster.

Our task must be to free ourselves . . . by
widening our circle of compassion to embrace
all living creatures and the whole of nature
in its beauty.

—Albert Einstein

Curious Eyes

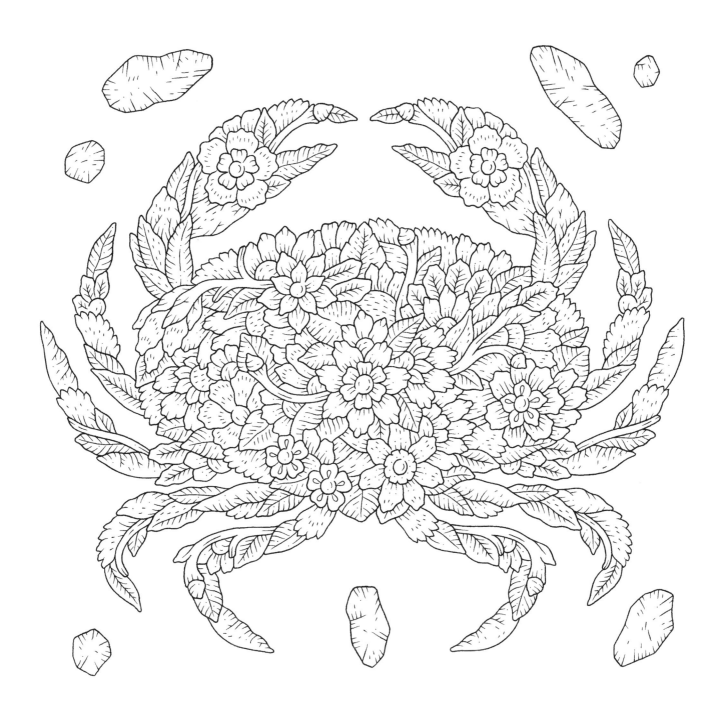

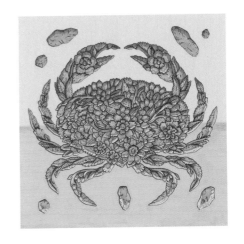

Accents of bright yellow and a wash of gentle pink add warm, almost volcanic movement to this crustacean scene.

The sea! the sea! the open sea!
The blue, the fresh, the ever free!

—**Barry Cornwall, "The Sea"**

Happy Crab

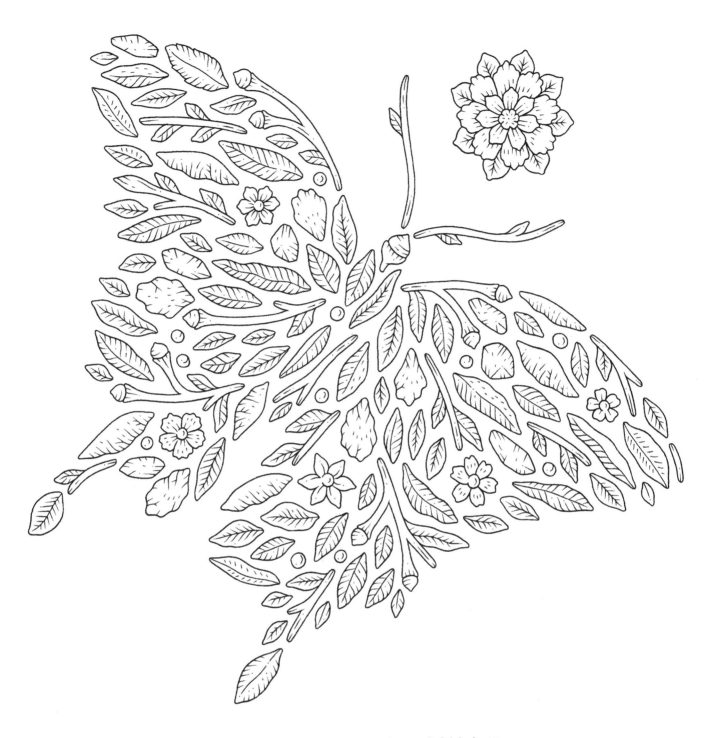

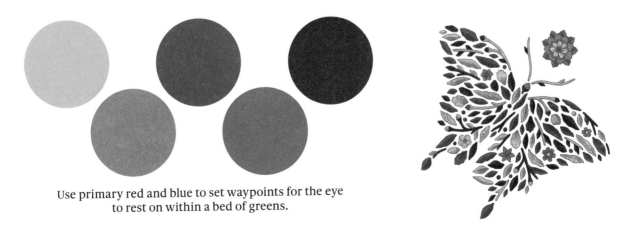

Use primary red and blue to set waypoints for the eye
to rest on within a bed of greens.

Butterflies lead you to the
sunny side of life. And everyone
deserves a little sunshine.

—Jeffrey Glassberg

Flying Flower

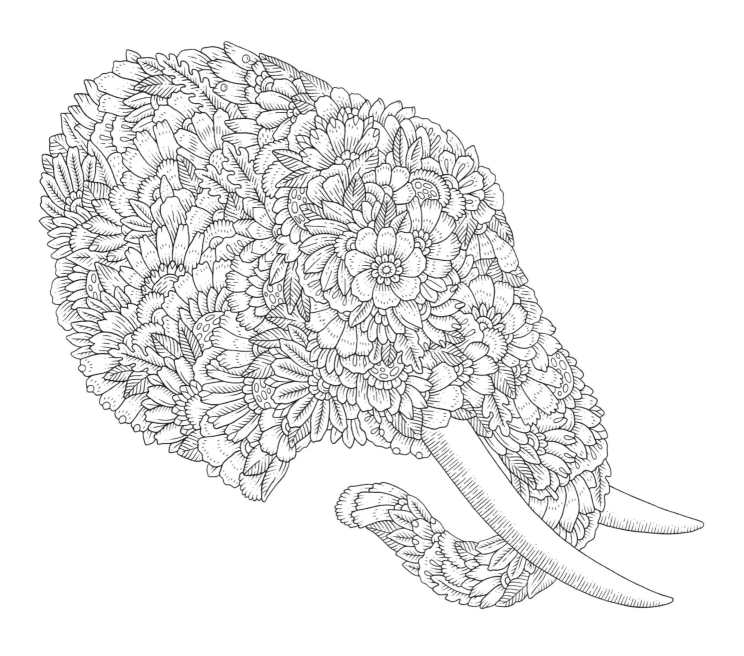

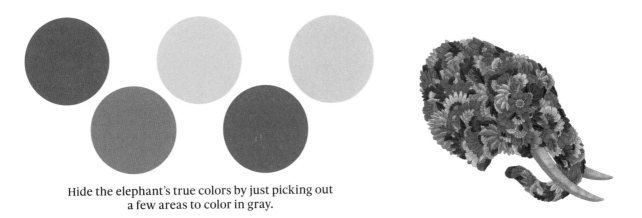

Hide the elephant's true colors by just picking out
a few areas to color in gray.

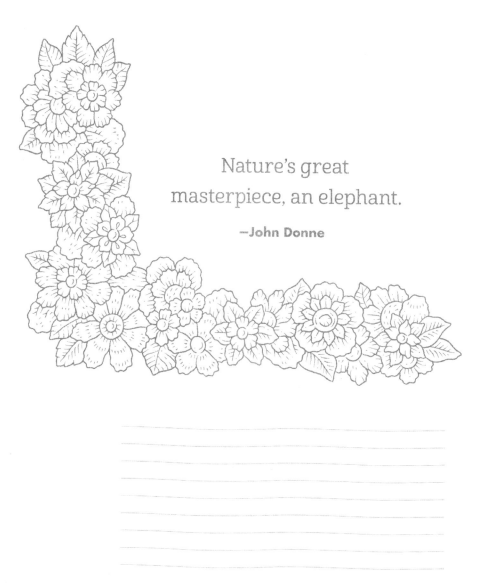

Nature's great
masterpiece, an elephant.

—John Donne

Elephant Blooms

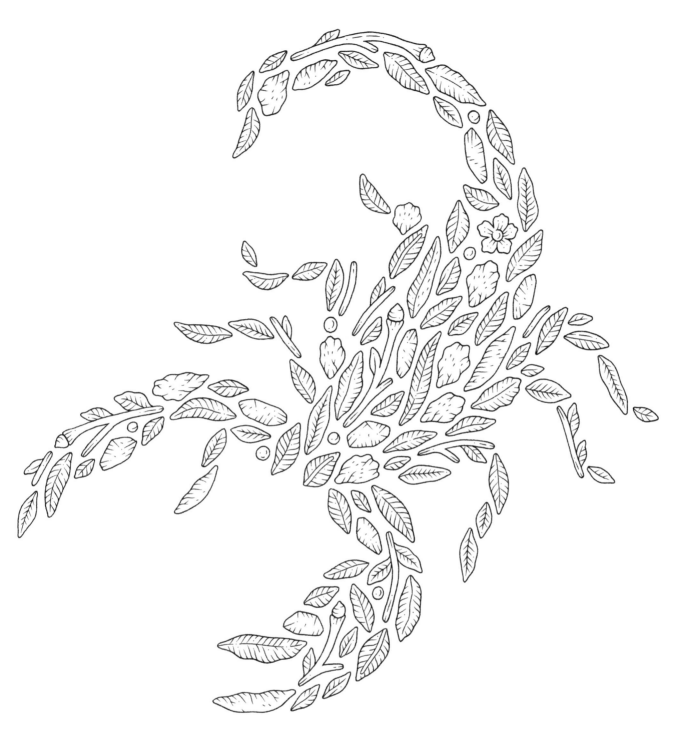

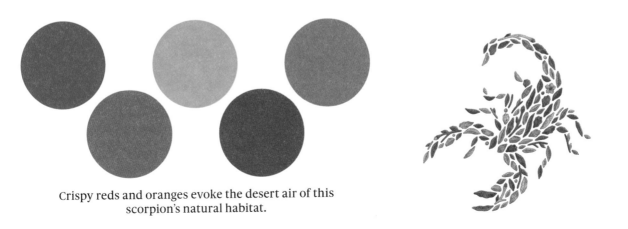

Crispy reds and oranges evoke the desert air of this scorpion's natural habitat.

I don't need people to keep them as pets. I
just like them to be respectful and see that
everything in nature has its place.

—Dominic Monaghan

The Sting

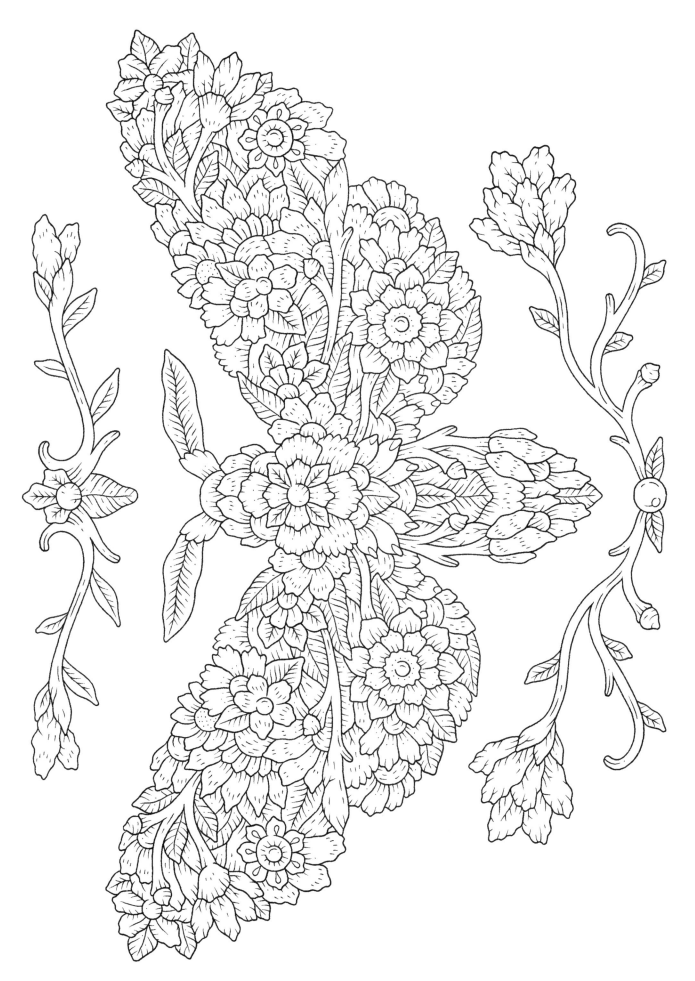

Always be a first-rate version
of yourself and not a second-rate
version of someone else.

—Judy Garland

Spread Your Wings

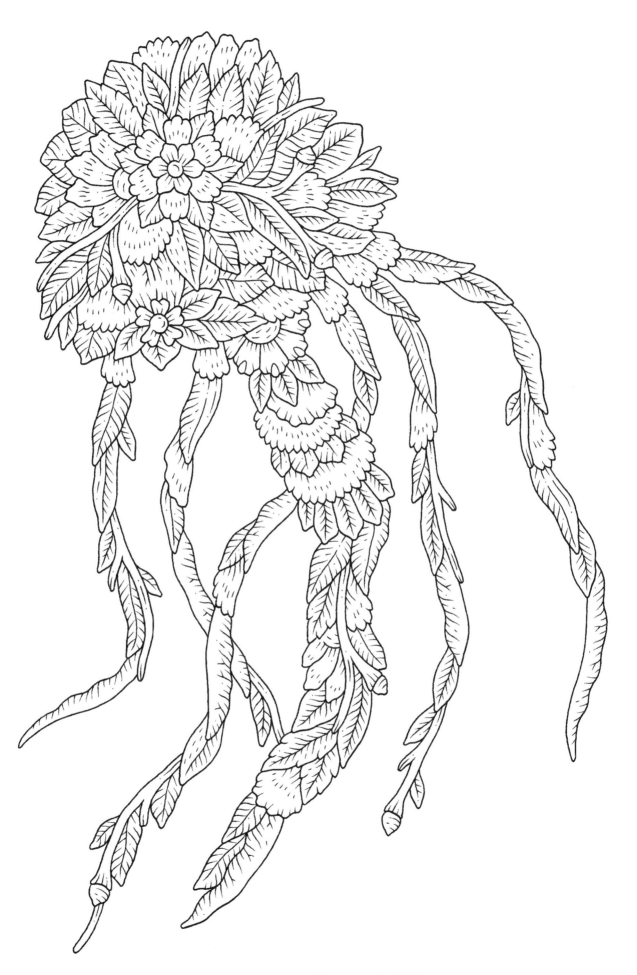

Honesty and transparency make you vulnerable. Be honest and transparent anyway.

—Mother Teresa

Jelly Swish

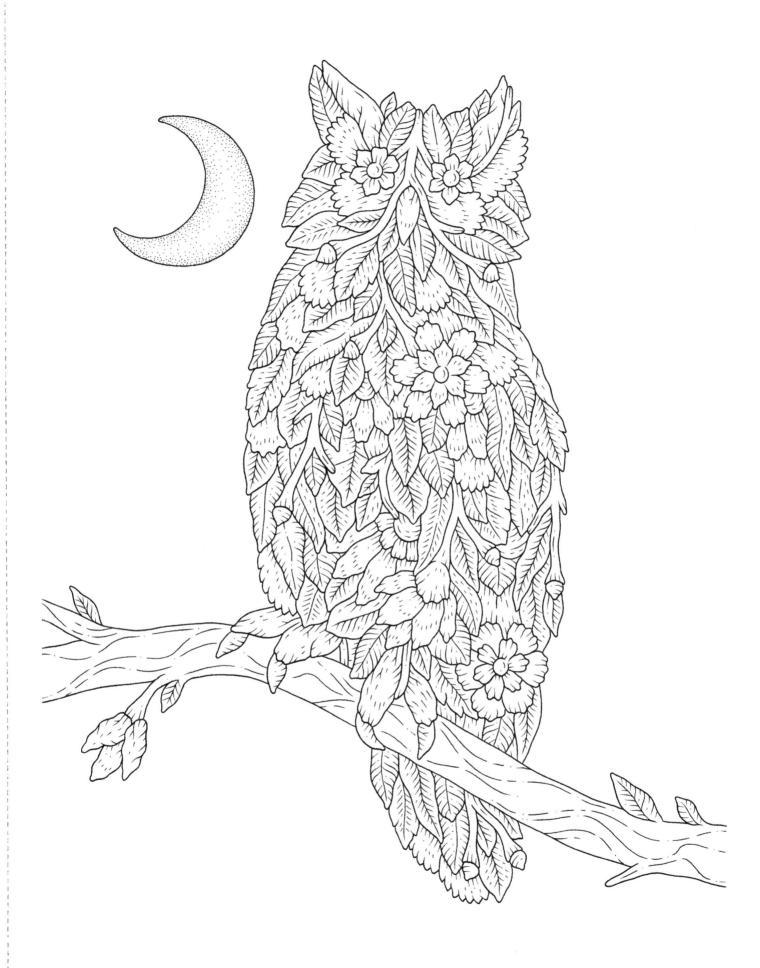

When the owl sings,
the night is silent.

—Charles de Leusse

Night Owl

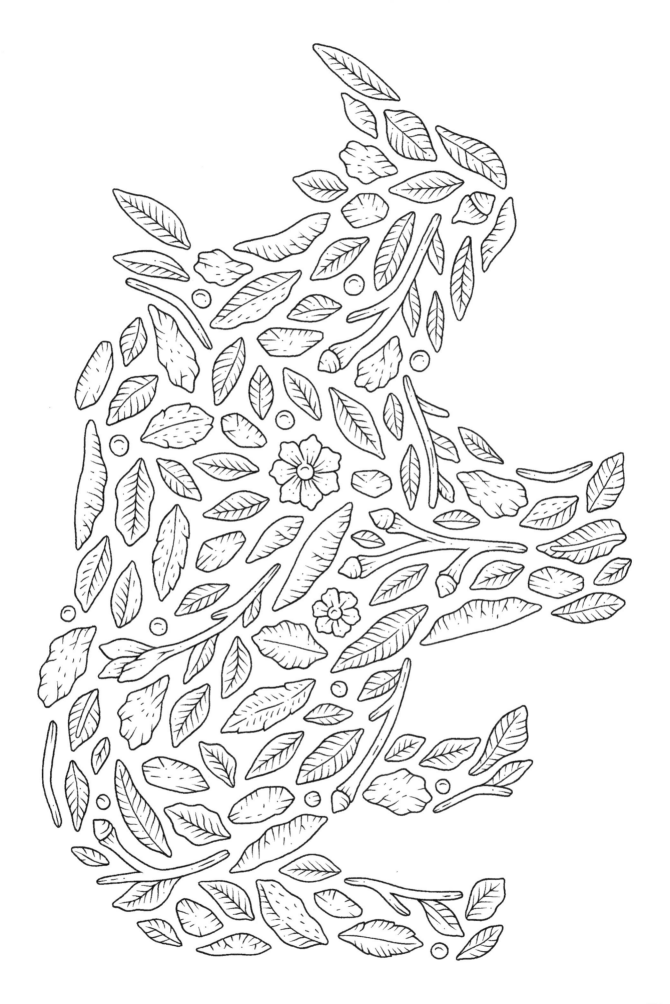

In Wildness is the
preservation of the world.

—Henry David Thoreau

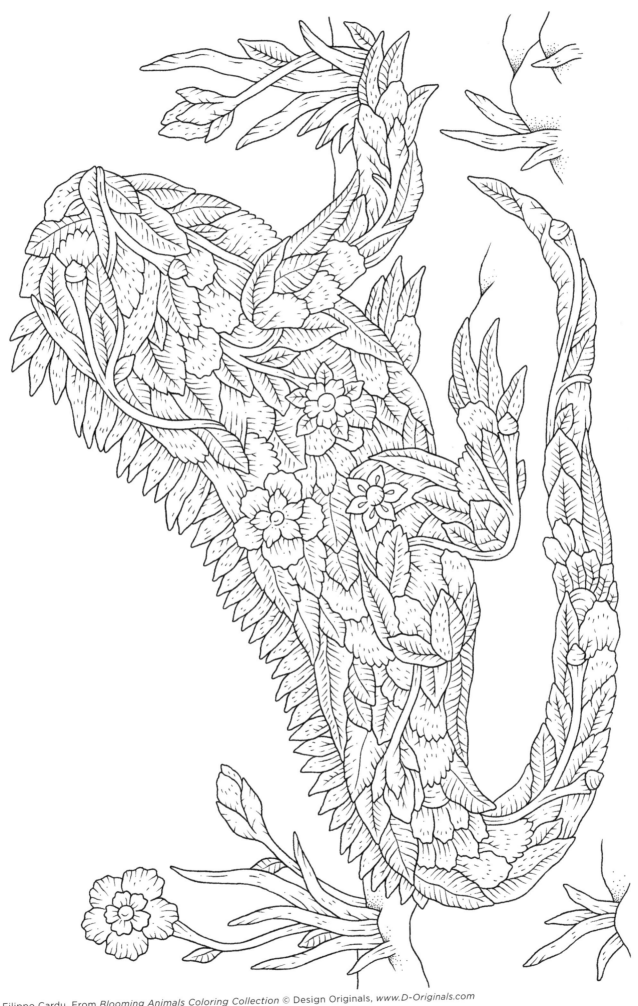

To see what is in front of one's nose needs
a constant struggle.

—George Orwell, "In Front of Your Nose"

Sunbathing

Strength lies in differences,
not in similarities.

—Stephen R. Covey

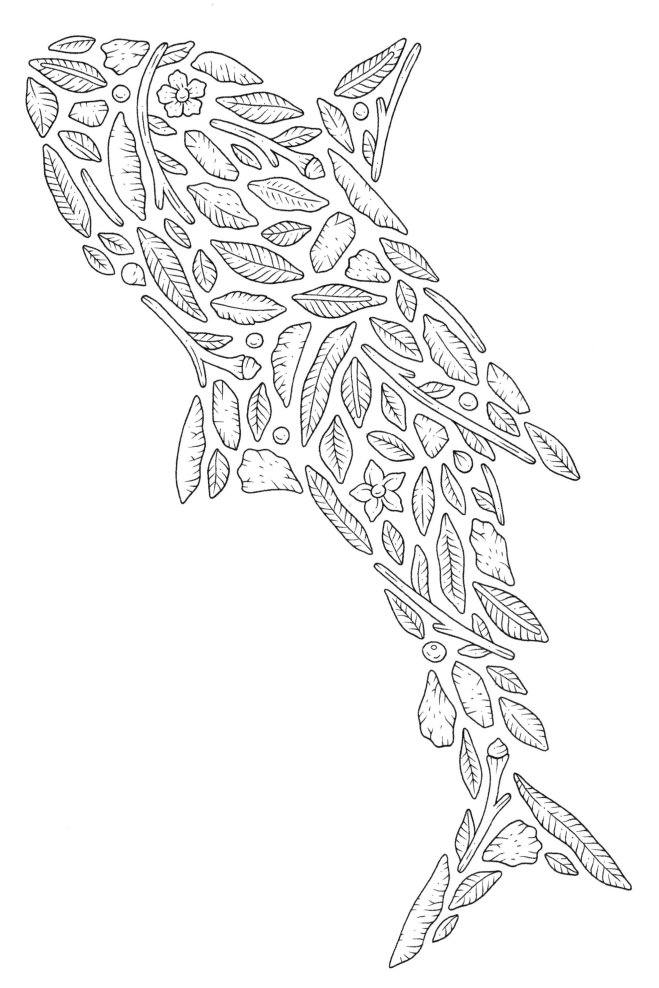

Sharks have everything
a scientist dreams of. . . . They're like
an impossibly perfect piece of machinery.
They're as graceful as any bird.

—**Peter Benchley**

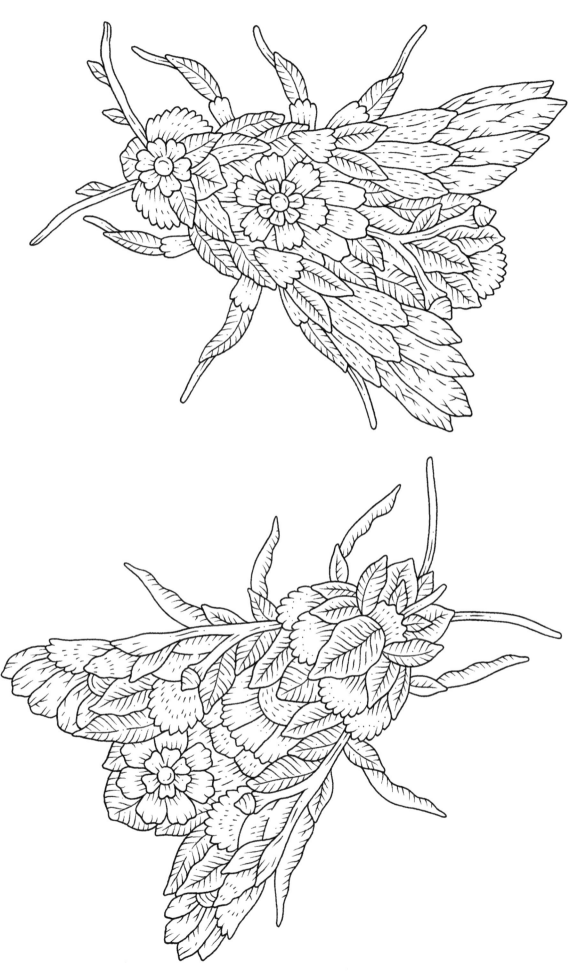

63

Friendship . . . has no survival value; rather, it is one of those things which give value to survival.

—C.S. Lewis, *The Four Loves*

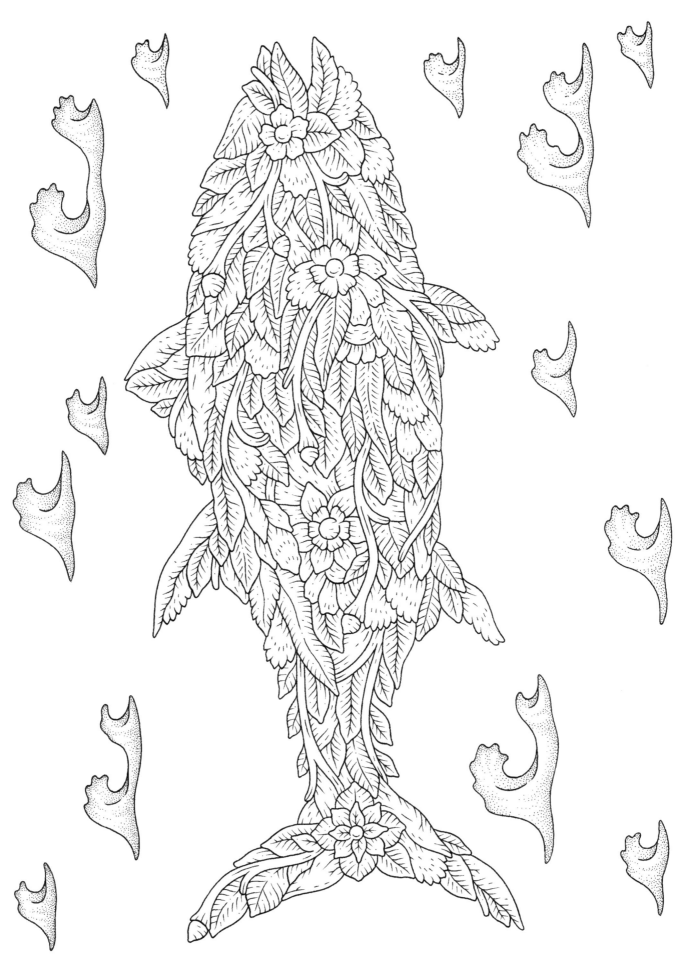

The world's finest wilderness lies
beneath the waves.

—Wyland

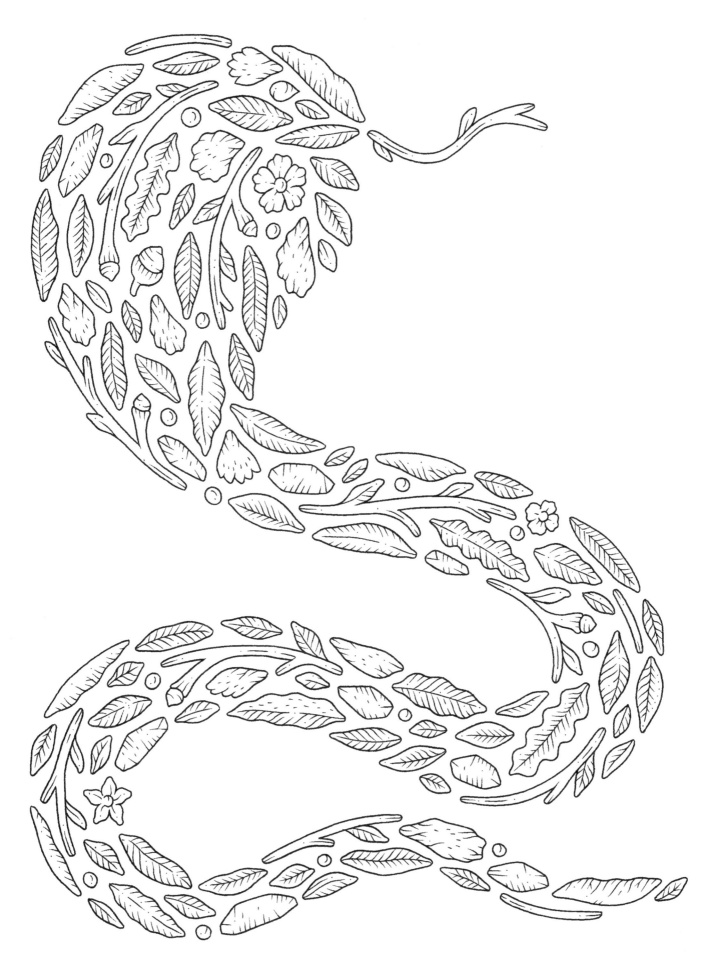

If we can teach people about wildlife,
they will be touched. . . . Humans want
to save things that they love.

—Steve Irwin

Slithering Grace

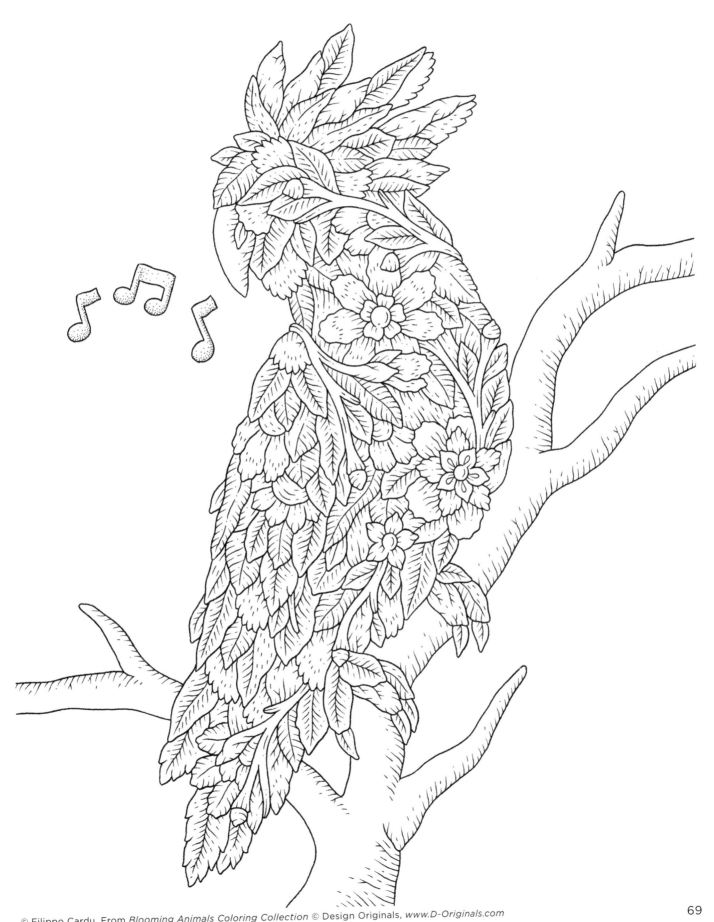

A bird is three things:
Feathers, flight and song,
And feathers are the least of these.

—Marjorie Allen Seiffert

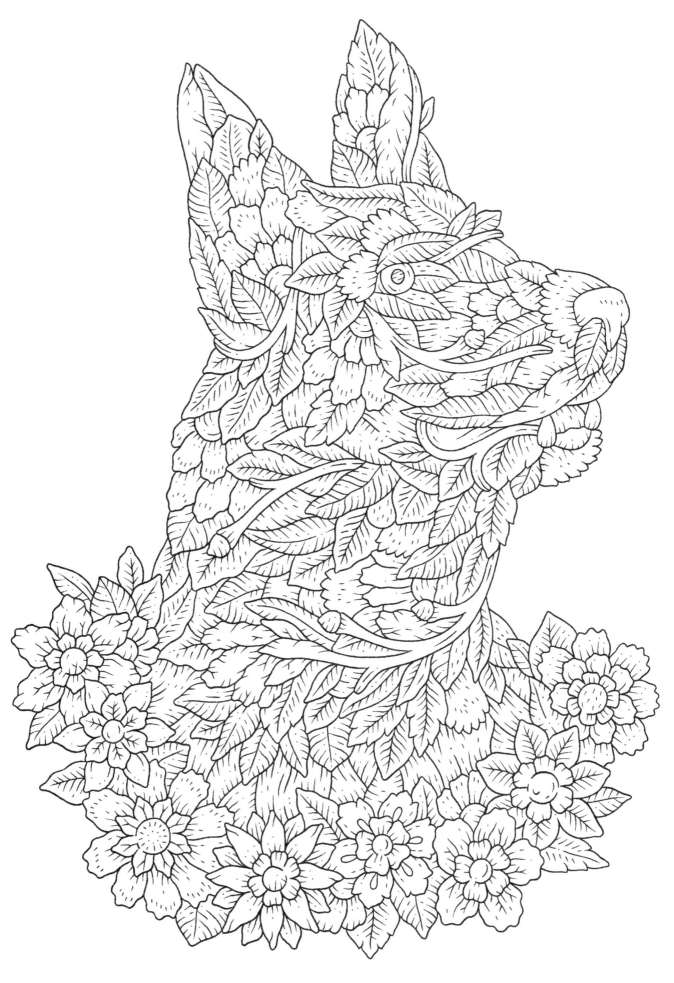

Dogs don't rationalize. They don't hold anything against a person. They don't see the outside of a human but the inside of a human.

—Cesar Millan

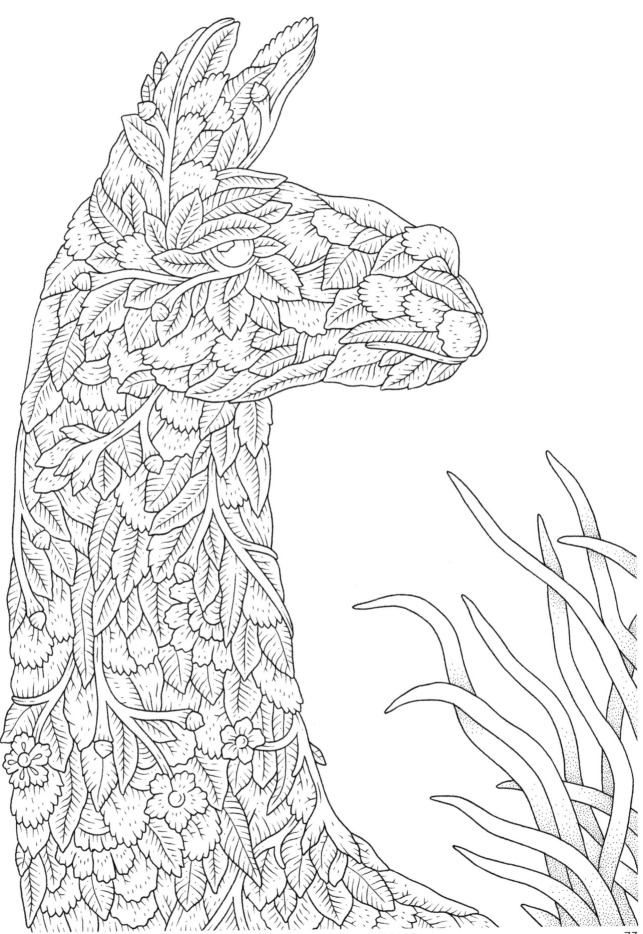

This is what you shall do:
Love the earth and sun and the animals.

—Walt Whitman

The Regal Llama

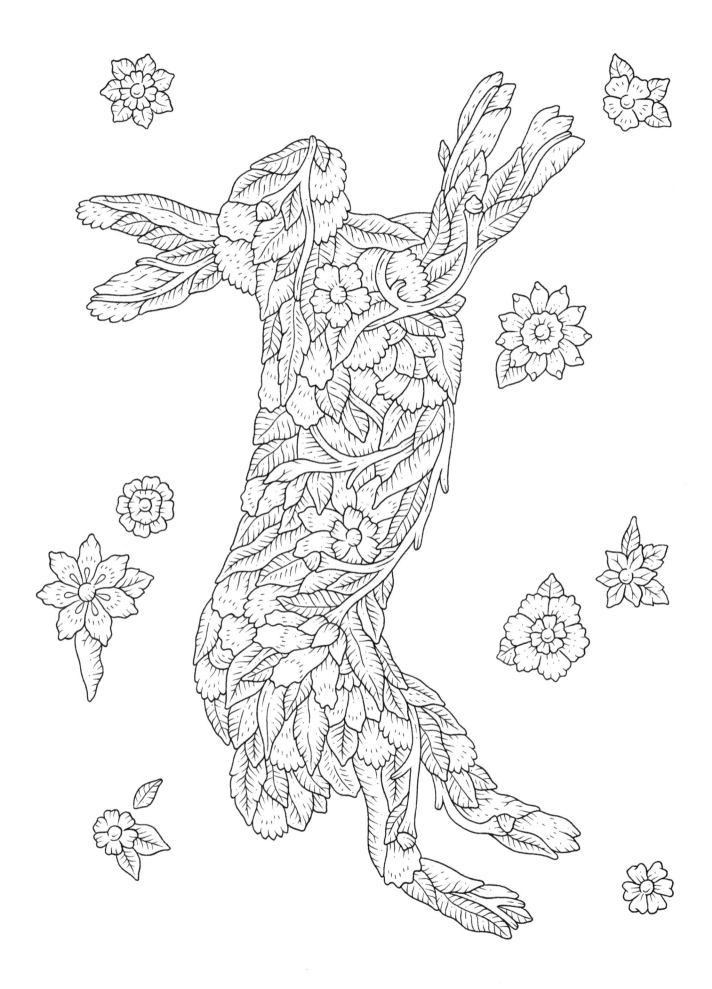

Go fast enough to get there,
but slow enough to see.

—Jimmy Buffett, "Barometer Soup"

Bunny Leap

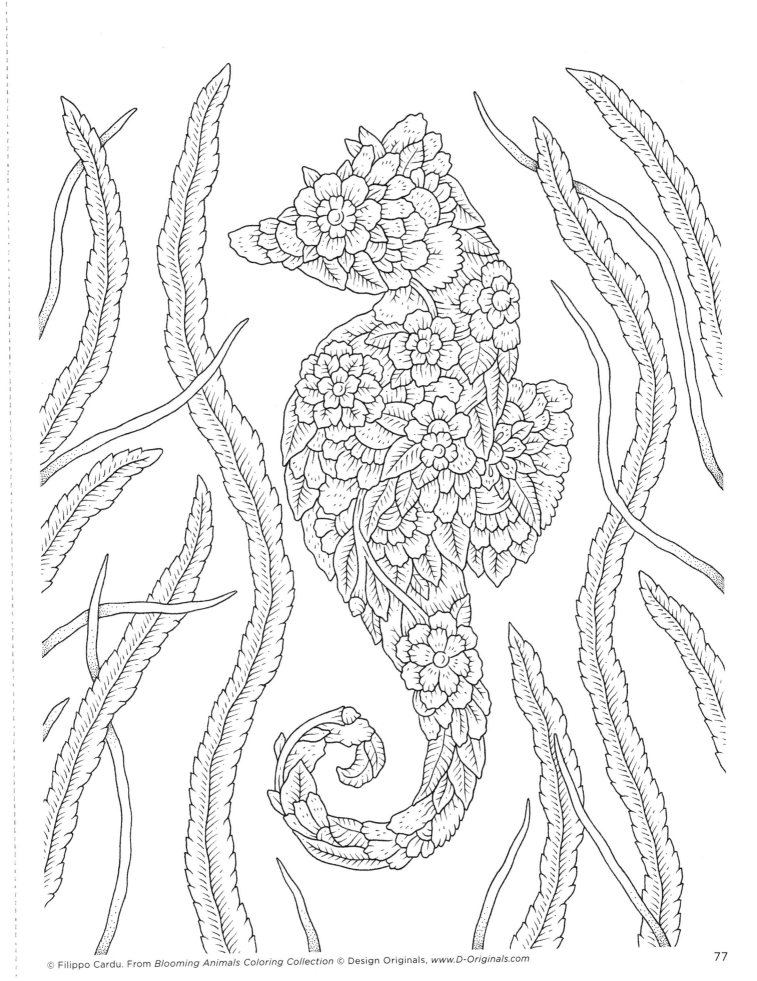

Some of nature's most exquisite
handiwork is on a miniature scale.

—Rachel Carson

Seahorse Beauty

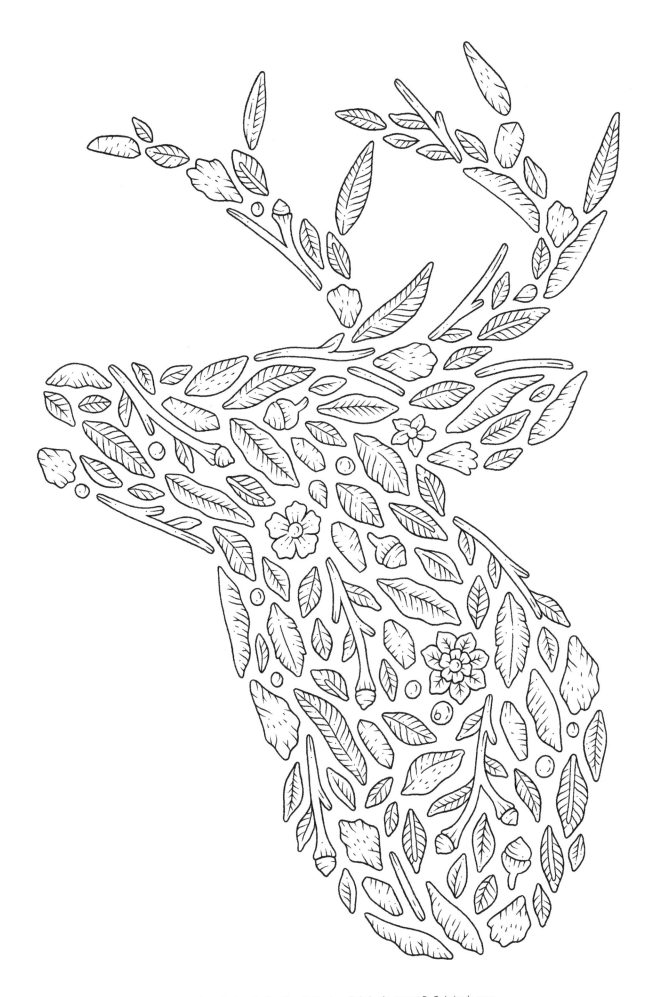

There are no words that can tell the hidden spirit of the wilderness, that can reveal its mystery, its melancholy, and its charm.

—Theodore Roosevelt